for Rick —
a fellow photographer,
I hope you enjoy these
images from decades ago.

2018

RECOVERED MEMORY
New York & Paris 1960–1980

PHOTOGRAPHS & TEXT BY FRANK VAN RIPER
Foreword by *Martin Walker*

Daylight

Frank Van Riper

Cofounders: Taj Forer and Michael Itkoff
Creative Director: Ursula Damm
Copy Editors: Nancy Hubbard, Barbara Richard

© 2018 Daylight Community Arts Foundation

Photographs © 2017 by Frank Van Riper

Foreword © 2018 by Martin Walker

"Recovering Memory One Image at a Time," "First
Impressions, Lasting Memories," "Transatlantic
Attitude,""Belly Up to the Bar, S'il Vous Plait," "Root Canal in
Paris," "Hot Type," "Subway: The Bronx Is Up; So Is the Gare
Du Nord," "Champs-Élysées of the Bronx," "Of Bicycles and
Baseball," "Coney Island, The Mythical Beach, and Brooklyn's
Eiffel Tower," "Epilogue"
© 2018 by Frank Van Riper

ISBN 978-1-942084-54-9

Printed by Artron, China

Daylight Books
E-mail: info@daylightbooks.org
Web: www.daylightbooks.org

This book is dedicated to the memory of
Frank Jackman, former overnight editor, United Press
International, and, later, Washington Bureau news
editor of the New York Daily News.
There, Frank helped form me as a reporter. Many
years later, when I succeeded him in the editor's chair,
I tried mightily every day to fill his shoes.

Pax tibi, my friend

FOREWORD *Martin Walker*

At the age of fourteen, I made my first visit to Paris, going by ferry boat across the Channel to Calais and then a steam train to the Gare du Nord. On the platform, along with my schoolmates, we met the various French families who would host us for the next three weeks. We also met the Parisian schoolboys who would return to spend three weeks with us in Britain.

My exchange student was called Claude. We were ill-matched. I was a very young and undersized fourteen, just out of short trousers and my voice had yet to break. Claude was almost two meters tall, had a pompous manner and a big nose that made him look like a young Charles de Gaulle. He wanted to be a paratrooper and go to war in Algeria. This was curious, since some leaders of the French army in Algeria had just launched a military coup to protest President de Gaulle's announcement of formal negotiations that would lead to Algerian independence.

So my Paris is not just the glories of the Louvre and Les Invalides, the scents of food and the Metro's smell of body odor, perfume, and black tobacco. It includes the memory of police stations guarded by sandbags and machine-gun nests and of *paniers a salade* (as police vans were known) being stuffed full of Algerians rounded up from cafés. Since Claude enjoyed such sights, he liked to make us walk along Batignolles to Place de Clichy, past the Moulin Rouge and along to Pigalle where he would ogle the overpainted and underdressed women who lounged by doorways. I preferred the pastry shop at the bottom of the Rue Lepic's steps up to Montmartre, which made the best *tarte au citron* I have ever had. My first real coffee, my first smell of a hot croissant, my first glass of wine, my first cigarette, my first game of pinball; I learned a lot from Claude.

Three years later, I made my first trip to New York, wearing the uniform of a cadet in the Royal Air Force as part of a NATO exchange. We were installed in the Waldorf Astoria and I had never seen a bathroom like the one I saw there, never thought such luxury existed. The cars were enormous and the steaks likewise. The buildings were impossibly high, the cops looked tough, all the men looked busy, and the women seemed to have been polished and their hair sculpted. *The Daily News* was even more brash than I had been told, the skyline more spectacular, the voices louder and the breakfasts more gargantuan. It was just how New York was supposed to be, in your face and larger than life.

It may be because I fell in love with these two cities as an adolescent that I find Frank's photos so powerful, not just as triggers of memory and nostalgia of place, but of the tastes and smells and feel of another time. And the cities felt in some profound way to be siblings. Paris was the big sister, the capital of Then; New York was the precocious

kid brother just come into his full size, the capital of Now. One reeked of history, the other of the immediate and tumultuous present. Paris was tamed; New York still wild.

They were still cities that were not just visibly but tangibly composed of neighborhoods. You could never mistake Pigalle for Montparnasse, nor Belleville for the Marais. The architecture was different, along with the accents, the street theater, the look of the girls, the watchfulness of the eyes of the guys at the ridiculously tiny tables outside the cafés. Every quarter had its own personality and its own specialities in its own markets. The Tunisian pastries you found at the Marché aux Enfants Rouges along the rue de Bretagne were never available at the Marché Edgar Quinet in Montparnasse, which was the place for chocolates, just as you went to the Marché d'Aligre at Ledru-Rollin for the street musicians and the Marché Bastille for the performers, from mime to escapologists.

In New York there was a real Chinatown, a Little Italy that still had wise guys, a theater district, and only one Village. And as Leonard Cohen later was to sing, there was music on Clinton Street all through the evening. Yorkville still had diners with German food and women were still banned from McSorley's Ale House. You could still find the dive on 52nd Street where W. H. Auden greeted the imminence of World War II, "Uncertain and afraid, At the end of a low, dishonest decade." NYU and Columbia and the mega-hospitals had not quite requisitioned their respective districts. The subway didn't feel quite as antique as it does today, there were phone kiosks on almost every corner, and the cab drivers smoked cigars.

The two cities took their politics seriously. I remember being in one march against the Vietnam War with Jean-Paul Sartre, Jean-Paul Belmondo, and Jeanne Moreau. Later in that summer of 1968 I watched workmen digging up the *pavés*, the stone blocks that paved so many of the streets, so the demonstrators of May 1968 could never again dig them up to build barricades to hurl against the riot police. We tend to forget that *les événements* began with students at Nanterre University protesting the Vietnam War just as the Paris Peace Accords were getting under way, one of the triggers that became something close to a revolution that forced de Gaulle to flee Paris. We forget also that after protesters beat back the riot police on the night of May 10, the Latin Quarter was briefly renamed the Heroic Vietnam Quarter. A few years later I watched the Vietnam Veterans Against the War march on the New York City offices of the Committee for the Re-Election of the President.

As I grew older, my later times in Paris and New York shifted my perspective when I realized that like all the great conurbations they were river cities with islands and bridges and waterfronts. I still tell my kids about one great landing that I made in New York in 1971, aboard the SS *France*, sailing past the Statue of Liberty and Ellis Island to dock at the Manhattan wharf. And then without a break the reminiscence continues to Paris

on July 14, 1989, the two-hundreth anniversary of the fall of the Bastille when with other members of the White House press corps I lay prone on the roof of a houseboat on the Seine to watch the world's most spectacular fireworks display exploding above and around the Eiffel Tower that was just nearby.

Another thing the two cities have in common, which I discovered in my later years, is their remarkable cemeteries. We all know Père Lachaise for the graves of Jim Morrison and Oscar Wilde, Chopin and Edith Piaf and the wall where the last of the militants of the Paris Commune were shot by French troops in 1871. But I have a soft spot for Woodlawn in the Bronx, less for the Egyptian temple and the sphinxes who guard the remains of F. W. Woolworth than for the more modest but moving graves of Duke Ellington and Miles Davis, within horn-tooting distance of each other.

That's another piece of soul the two cities share, the Parisian love affair with American jazz, and the way that from Josephine Baker to Billie Holiday, Dexter Gordon to Bud Powell, Charlie Parker to Miles Davis, the French capital became more than just a venue, a sanctuary, for some of them a home. Most of them stayed at the Hotel la Louisiane on the rue de Seine. The place should be a binational shrine. Until then, we can more than get by just diving into Frank Van Riper's keen-eyed and touching tribute to the real twin cities.

MARTIN WALKER *is an internationally renowned journalist and foreign policy scholar and author of the bestselling* Bruno, Chief of Police *series of crime novels set in the Périgord region of France.*

RECOVERING MEMORY ONE IMAGE AT A TIME

In working on a book of photographs I made decades ago, I was confronted by one stark fact: You can't go home again. That is, with all my other books, if a particular image didn't work, I could retake it next time. In the case of *Recovered Memory*, however, my universe of images was limited totally and absolutely to what I already had shot—more than a half century ago in New York City; some forty years ago in Paris. Barring my sudden invention of a time machine, there simply was no way I could expand on this archive. So that meant I had to extract the most that I could—i.e., cull the best photographs from a necessarily limited universe—under what just a few years ago might have been impossible circumstances.

But first, some history.

Why New York and Paris? New York is simple: It's what I am. I was born in Manhattan and grew up in the Bronx, just blocks from Yankee Stadium. New York is in my blood, along with egg creams, the *Daily News*, the subway, pastrami, and cannoli. Paris came more slowly, after my friends Neil and Carol Offen moved to France in 1976 for what would be a nine-year stay, first in Paris and then in Provence, after which they wrote an amazing (though sadly unpublished) book about France and the French of their day. My frequent visits to these New York–born Francophiles helped form my appreciation—and ultimately my love—of Paris.

"New York is nothing like Paris; it is nothing like London," the writer E. B. White said in *Here Is New York*, his eloquent post–World War II essay on the city. "[A]nd it is not Spokane multiplied by sixty or Detroit multiplied by four."

Not to disagree with one of the great essayists of his century, but New York *is* like Paris, or at least it was. Each city in its way is a beacon of style, culture, brashness, and charm. In addition, each is ever-changing and each bounces neatly off the other. I come naturally by my love of New York, having been born there. Though I have traveled and photographed in other parts of France, Paris always drew me back—as perhaps it would any New Yorker. I love Paris for its beauty, its style, its elegant symmetry; and yes, even for its subway. The shooting trips I made there some four decades ago produced a visual archive that I hope rivals my best work in New York.

Over the years, as Neil Offen observes, both Paris and New York have changed enormously, and probably in tandem. "They have both become wealthier, more gentrified, and more full of immigrants, and in a number of ways, more similar than they used to be. American culture—that is, New York culture—has invaded France and Paris through

the Internet, social media, cable TV, BBQ sandwiches. They have grown closer together and, perhaps, farther away from the rest of their respective countries."

The ten-year difference between my New York and Paris photography simply reflects my life at the time. In the 1960s, when I started making my New York photos, I was a student at City College of New York (CCNY) in Manhattan, where I was editor-in-chief of its undergraduate newspaper, *The Campus*. Within ten years I had become a reporter in the New York *Daily News* Washington bureau, had married my (first) wife and was traveling regularly to Paris, a city that drew me like a magnet.

Paris was a city where, unless you tried to have it otherwise, no one knew your name. Much more formal than New York, at least back then, even neighbors did not invade one another's space. My friends recalled seeing their next-door neighbors almost every day, yet never once did their French contemporaries ever say more than a coolly formal "bonjour, monsieur; bonjour, madame."

But that also meant that you were free to wander Paris's ancient streets, cross its beautiful bridges, linger in its myriad cafés, meander along the Seine, in wonder and anonymity. The subway vaguely resembled New York's, but back then at least some of the trains ran on rubber tires, and you still could find the occasional wooden subway car, usually the *first class* cars (an "only-in-Paris" anomaly that would fall flat on its ass in the Apple). The rush hour crowds were very much like New York's back then: people buried in their newspapers (not their iPads or smartphones), the atmosphere occasionally punctuated, it must be said, by body odor and garlic breath.

I say this not in condescension, for Paris also was a city that graced its subway stations with near full-size replicas of Rodin's great sculptures at a time when New York's subways and stations too often were slimed by garbage and graffiti.

"On any person who desires such queer prizes, New York will bestow the gift of loneliness and the gift of privacy," said E. B. White. "[T]he residents of Manhattan are to a large extent strangers who have pulled up stakes somewhere and come to town, seeking sanctuary or fulfillment or some greater or lesser grail. . . . No one should come to New York to live unless he is willing to be lucky."

By contrast: "Paris, we came to believe, has more people living there against their wishes than any other city," wrote the Offens in their manuscript for *C'est La Vie: An Intimate Portrait of the French Today*.

For many of these reluctant Parisians, there was no other choice. Paris remains today the intellectual, journalistic, financial, artistic, fashion, and culinary capital of the entire country—no other city in France even comes close. And any who wanted to make their name in these fields simply had to live there, expense be damned, or at least endured. Not for nothing does one say "going up to Paris" regardless of location, just as anyone leaving from this favored place is always "going down."

"According to several recent surveys," the Offens wrote, "the French by an overwhelming vote would choose to live in a medium-sized city rather than in the capital." The lovely Provençal town of Aix-en-Provence was the dream location for most French, "but the Parisians realize they have to be [in Paris]. There haven't been many options for them."

Contrast this with the diversity of opportunity that exists in other countries, not just the United States. In Italy, for example, the culinary center is Bologna, the fashion center is Milan. The artistic center is Florence and the government/financial center is Rome.

Even in England—where London simply dominates the country's financial and political worlds—Manchester is the center for sports and Cambridge and Oxford are the centers for learning.

New York may be the self-proclaimed center of the universe, but there are any number of other great American metropoli—Chicago, Los Angeles, San Antonio, Philadelphia, and Boston, to name only a few—in which one can succeed on one's talent and tenacity without having to pay Manhattan—and now Brooklyn—rents.

Then there's the weather. I remember visiting Neil and Carol in Paris one spring and being struck by how easily the weather in Paris could turn nasty. Welcome to our world, they said. "Whoever wrote 'April in Paris,'" Neil observed (nb: Vernon Duke/Yip Harburg) "was never in Paris in April".

Parallels like these—as well as the contrasts—between these two great cities inspired this book.

Any work of documentary photography, especially when dealing in the past, also is a catalog of missed chances. Sure there are photographs I wish I had made. All the more reason, then, to get the most out of what I had.

Praise here for my Epson flatbed scanner that almost miraculously drew as much detail as possible out of woefully faded Ektachrome transparencies, or thin black and white negatives. This in turn allowed me far more leeway than I ever could have in a conventional wet darkroom to control tone, saturation, contrast, and relative exposure levels in my final digital prints—while never adding or deleting elements to alter the essential truth of the image. Once these images were "developed" to my liking on my calibrated Mac desktop, I was able to produce archival prints to supplement the portfolio of black and white silver prints that I had made in the darkroom.

As I completed work on the archive of these vintage images, another fact became blindingly clear: The only constant in life is change. *Everything* will be different sooner or later, so that photos made years ago have intrinsic value *simply because* they reflect a time and conditions that are gone forever. Granted, this means that even a mediocre snapshot has merit for the insight it provides into the past. But on those very rare occasions when you find an image that twins historical relevance with grace, or even at times beauty, one only can be grateful.

FIRST IMPRESSIONS, LASTING MEMORIES

THE CITY OF (MAGICAL) LIGHT

The first thing that struck me—on that first cab ride into Paris from Charles De Gaulle airport more than forty years ago—was the light. A glorious golden raking light that bathed everything before me in a warm wash that highlighted detail and accentuated form. The buildings, the bridges, the boulevards that whizzed past me—these were impressive enough, especially to a first-time viewer—but that odd morning light made everything more dramatic.

Adam Gopnik, the *New Yorker* writer who lived in Paris with his young family twenty years ago, remarked on this, too, but at the other end of the day. In *Paris to the Moon*, the memoir he published in 2000, he observed that, "Paris is a northern city, on a latitude with Newfoundland, as New York is a Mediterranean one, on a latitude with Naples, so the light here in the hours between seven and nine at night is like light in the hours between five and seven in New York."

Parse that back toward the morning and you find that light in Paris between eight and ten in the morning is much like that in New York between six and eight. In other words, the wonderful light of pre-dawn and sunrise, without having to wake up with the sun.

I knew then that I was going to love Paris.

INTELLIGENCE GATHERING

In 1962, President John F. Kennedy, hosting an audience of Nobel laureates, said: "This is the most extraordinary collection of talent, of human knowledge, that has ever been gathered together at the White House, with the possible exception of when Thomas Jefferson dined alone."

Kennedy, himself a Harvard-educated Pulitzer Prize–winning author (*Profiles in Courage*), was justifiably proud of the intellectual firepower of his presidential predecessors. Ulysses S. Grant, it should be remembered, wrote a nationally acclaimed autobiography, Woodrow Wilson had both a PhD and the Nobel Peace Prize, and Kennedy's immediate predecessor, Dwight D. Eisenhower, graduated West Point and later led the allies to victory in World War II.

Presidents after Kennedy—with some exceptions—also held academic distinction. Jimmy Carter was a nuclear engineer; George H.W. Bush, a Yale-educated former director of Central Intelligence; Bill Clinton a Rhodes Scholar; Barack Obama, president of the *Harvard Law Review*—and also a Nobel laureate.

Contrast that to today when, at this writing, the current occupant of the White House cannot remember the name of the last book he read.

Compare that, too, to what once had been the amazing literacy of French presidents.

It was not unusual, for example, to see then-President Valery Giscard d'Estaing discussing literature, not politics, on French television. So too did Francois Mitterand enjoy a superb reputation as a (non-ghosted) writer. And his perennial rival Jacques Chirac never lost any political points by often and publicly declaring his love for poetry.

In recent decades, however, as France's influence on the world stage waned, some have noted also a lessening of French (i.e., Parisian) brilliance among its political elites and the rise of what one scholar has called a "less meritocratic and more technocratic" political ruling class. Noted this critic: "The contrast in this respect between [former French presidents Nicolas] Sarkozy and [Francois] Hollande, who can barely speak grammatical French, and their eloquent and cerebral presidential predecessors is striking."

Still, no one in France has yet had to experience the contrast between Thomas Jefferson dining alone and a semi-literate president who can't stop tweeting.

THE AUTOMAT

For New Yorkers of a certain era, meal-time memory recalls doughy and dour women with gunmetal gray fingers.

These were the change-makers at Horn & Hardart, the seminal New York eatery where, besides the steam tables and Salisbury steak, there were myriad "automated" vending machines where sandwiches, small crocks of baked beans and pie could be liberated from their individual glass-fronted garages by the mere insertion of nickels. (Note: Though I am sure some of the change-making ladies were comely and smiling, in my memory they always are round, middle-aged, and very serious.)

"Automats" were first introduced in the city at Times Square in 1912, and were beloved during the Great Depression for their good, cheap, easily accessible food. They were an instant success. Combined with the take-home "less-work-for-Mother retail shops," the Automats knew their greatest popularity in Manhattan's victorious post–World War II boom economy—the dawn of the hurried white-collar lunch. By the 1950s, with more than fifty restaurants all over the city, they had become a New York icon, like the Staten Island Ferry, the Coney Island parachute ride—even the subway.

I can't remember how many meals I had there: first with my parents and later as a college kid. The steam tables were fine for the usual diner fare, but you could go to Bickford's or Schrafft's for that. It was the little glass cages—and the hand-cranked coffee spigots in the shape of tiny dolphin heads—that were the real draw. And for those you

needed nickels. The change-making ladies were always in the center of the restaurant, in an ornate, multi-sided kiosk, one lady facing out from each compass point. They stood before wide marble trays and when you handed one a buck, she would grab a handful of coins from her drawer and, sweeping her hand in front of her, deposit twenty nickels before you in a neat row, without ever breaking a sweat, or a smile. Doing that eight hours a day gave every change lady I met gunmetal gray, rubber-tipped fingers.

PROUST WAS RIGHT

Near the end of the 1972 presidential campaign, Democratic nominee Sen. George McGovern was having closed door meetings in Manhattan, so we in the traveling press corps were holed up in a cavernous press room in the New York Hilton to wait for him.

It was getting on to lunch time so rather than sit hungry at my portable typewriter at the back of the hall I did what any native New Yorker would do: I took the elevator downstairs, crossed the street to the Carnegie Deli and ordered a pastrami and chopped liver on rye to go. When I brought the sandwich back with me—and unwrapped it at my desk—I could see heads all the way to the front of the room jerking up and sniffing the air.

"What is that?!" my colleagues said. And soon they knew. The only other time I had such a transformative sandwich experience was when I sent a copyboy on a food run to Arthur Bryant's legendary barbecue joint in Kansas City in 1976 during the GOP convention.

Proust, of course, was right: one often associates smells and aromas with remembrances of things past. Just as the Bronx and Manhattan of my youth conjure the smell of great pastrami, so too does the heavenly aroma of fresh-baked baguettes bring me back to Paris.

In the Paris of my younger days, that smell was everywhere every morning. Each neighborhood had its own pâtisserie where one could walk in the morning—perhaps enjoying a café along the way—and return home with a still-warm baguette, or a few croissants or brioche. Similar olfactory ecstasy might be had in New York if you happened by a bagel bakery, but they never were as numerous as Parisian pâtisseries. And, in fact, Paris seems to have tumbled to the chewy joy of *le bagel*. As Charles Berberian, a Parisian cartoonist whose work often appears in *The New Yorker*, noted a few years ago: "I would have to go to Rue des Rosiers [in the predominantly Jewish Marais section] to get a bagel—now I can get one anywhere in Paris."

The passage of time *has* made French bread and New York bagels more accessible outside of their domains. One example is in Washington DC, for too long a culinary backwater, but now a fairly regular player in the food wars. I recall some thirty years

ago, the only croissants available in DC were sold in supermarkets two at a time in cardboard boxes with plastic windows. Compared to Parisian croissants the boxed breads were dreadful; compared to anything else available to me at the time, they were ambrosial. Eventually, a breadmaking genius (fanatic?) named Mark Furstenberg— who had studied breadmaking in California and in France—opened Marvelous Market on Connecticut Avenue in upper northwest Washington, a well-off part of town with more than its share of government officials, lawyers, and journalists. The place took off like a rocket, to the extent that there literally were bread lines out the door, and you were limited to one or two items at a time: a baguette and a boule, perhaps. (Yes, that really was Susan Stamberg of NPR standing patiently in the line, like a poor Cuban waiting for free food in Havana.) As competition increased, Marvelous Market grew too large and went bankrupt. But that didn't stop Furstenburg, who opened a smaller artisanal shop, Bread Furst, just a few blocks away, that seems to be doing just fine. Asked once whether there now was a bread revolution in America, Furstenberg wisely said, Hell, no. Doubtless recalling the A-list breadlines that he once had instigated, he declared: "Only in America could the most basic food of the peasants become upper-class food."

I will reserve a native New Yorker's judgment on whether Parisians will ever make a great bagel, however I do recall one time when Paris did seem to improve on one of its own inventions that had become an American staple.

It was in the early 80s and I was on the Champs-Élysées, amid the joyous hoopla that always attends the finale of the Tour de France as it nears the Arc de Triomphe. We barely could see the finishing cyclists through the cheering crowd on the sidewalk, but behind us there was no mistaking the familiar golden arches of Paris' first McDonald's.

What the hell, I said to myself.

The Big Mac was OK, but the French fries were glorious.

SIGHTSEEING

Of all the wonderful things I've seen in Paris, few compare with the serene beauty of the Musée Rodin in the heart of the city. It was the great sculptor's home and it is filled with his treasures. Rodin, I am happy to say, lived well and was celebrated during his lifetime. My favorite image: a picture I made of a guard sleeping in a chair, his head resting on his fist, unconsciously mimicking the pose of one of Rodin's most famous works, Le Penseur (The Thinker) sitting in maquette just a few feet away in front of an ornate picture window.

The most famous of Paris' attractions, Gustave Eiffel's tower, also was a must-see on my first trip, but not just to tour it: I needed to make a picture of it that literally had not been done a million times before. A brilliant blue sky provided me with a backdrop—but

it was a *soupçon* of puffy white cloud visible through only one part of the great tower that gave me my picture, once I isolated it through the now-abstract filigree.

Back then, one still could visualize Gene Kelly or Fred Astaire dancing at the base of the Tower overlooking the city. Not today. "Security has ruined the ease of being a tourist that I remember when I was first there at age fifteen," recalls photographer Erica Wissolik. "The Eiffel Tower is the best example. Long lines, tacky souvenir hawkers, soldiers with machine guns. . . ."

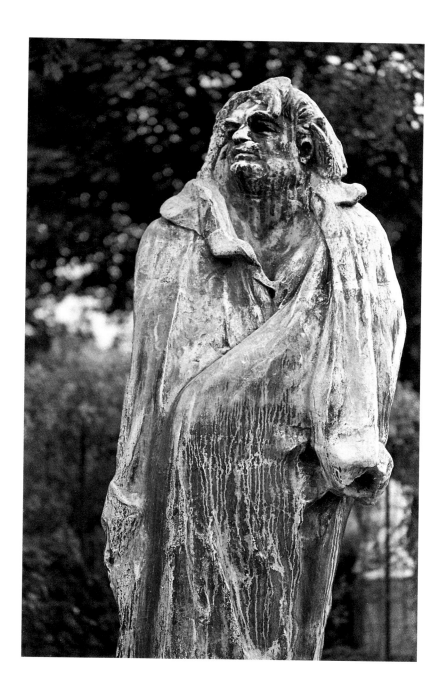

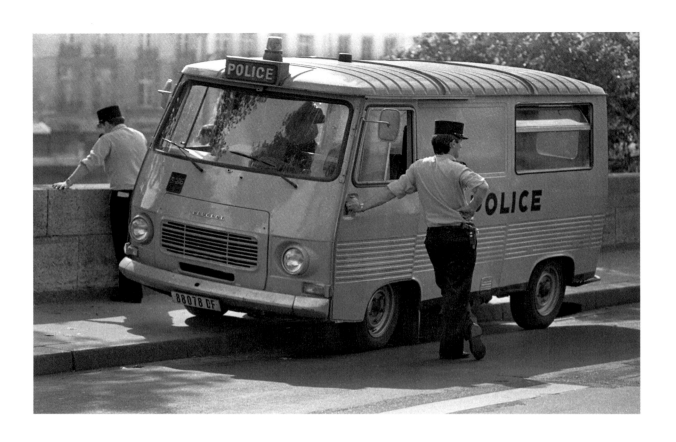

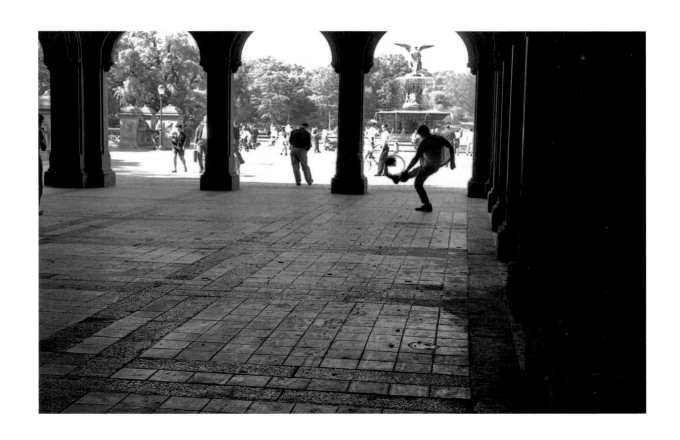

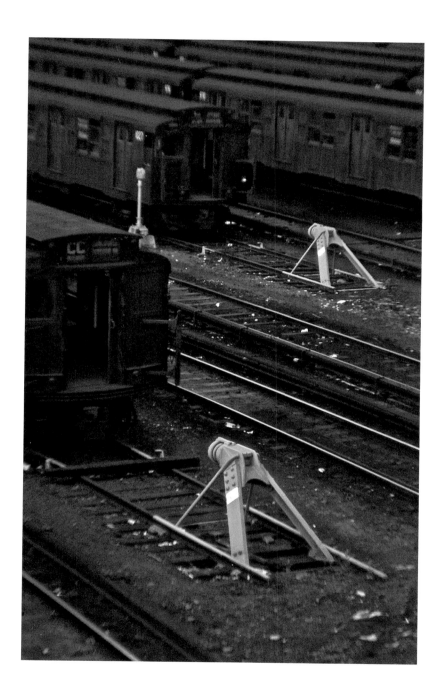

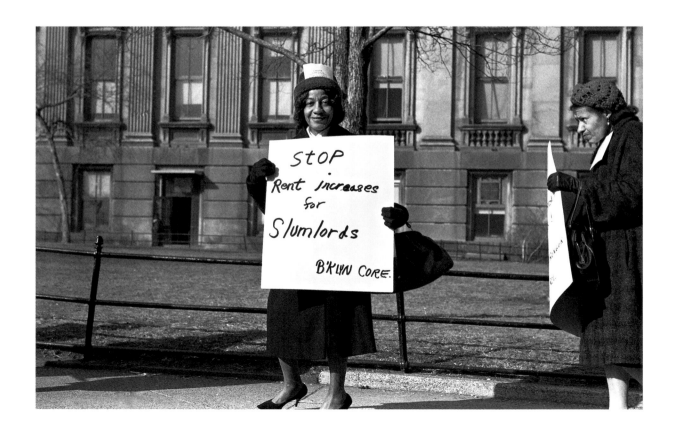

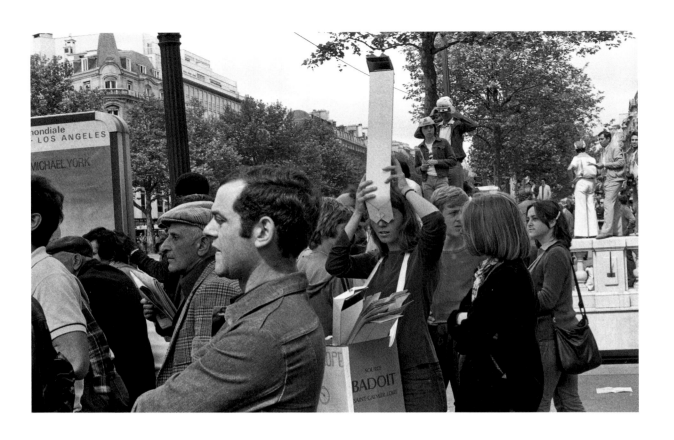

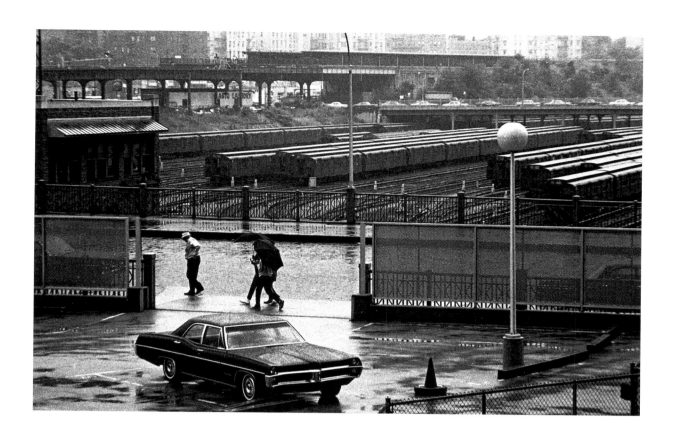

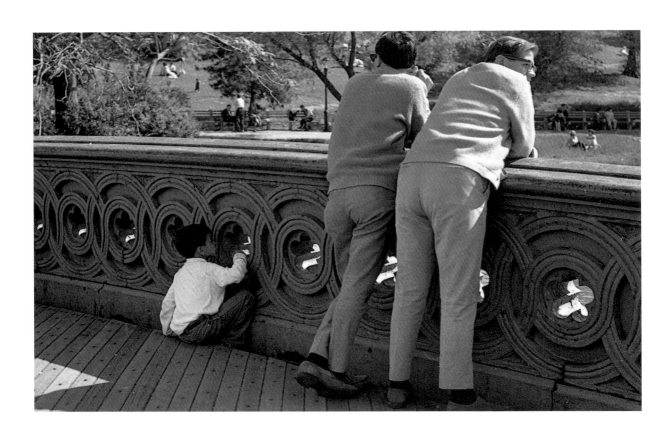

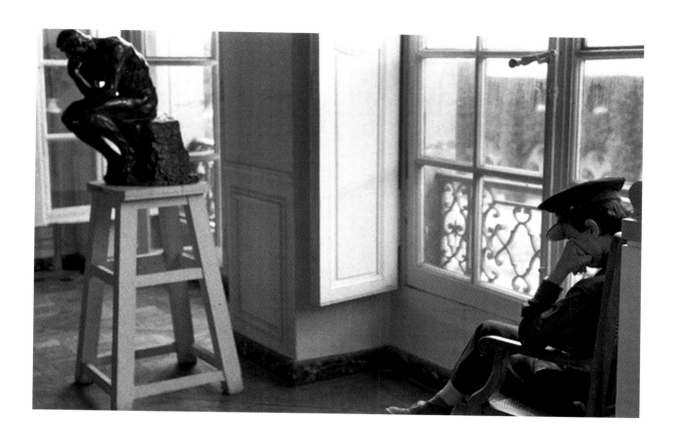

TRANSATLANTIC ATTITUDE

"Can I ask you for directions," goes the old joke about New York, "or should I just go fuck myself?"

In the south of France there is a word, *doryphores*, to describe Parisians. The word actually describes a rather unpleasant beetle, but among non-Parisian French it means someone who is "a questing prig" who loves pointing out the faults of others.

In fact, authors Neil and Carol Offen noted years ago, "Parisians generally are considered rapacious know-it-alls, sort of Gallic New Yorkers."

Clearly, New Yorkers and Parisians were made for one another.

And yet...

Two a.m.: West Farms Square in the Bronx, mid 1960s. At a corner all-night candy store an old beggar lady wants a Coke.

Guy behind counter: "Coke's ten cents."

"I just want sumthin' ta wet m'whistle," the old lady says in a wheezy rasp. Rather than ignore her or tell her to scram, the counter guy says, "Then I'll just give ya fi' cents woit." He mixes the drink in a white paper cone nestled in a metal holder. The drink looks an awful lot like a full one. I doubt he even took her money.

While stories of Parisian coldness, especially toward tourists and foreigners, certainly are true, they may be true only up to a point. Just as every New Yorker is not a loud, inconsiderate boor, so too every Parisian is not arrogant or distant.

"When we were there in 2010 after an absence of some twenty years, we were struck by how much more open and outgoing Parisians seemed," recalled Carol Offen. She noted, too, that this feeling was echoed by friends who also have lived in France.

"We were stunned to see Parisians picnicking on the grass in the Place des Vosges and even walking on the grass in the Tuileries. (Ed.: this was almost a hanging offense when I was there.)

"Partly, I think that's because the young people who had been so much more interested in Americans and in foreign travel back in the 80s have grown up and are now middle aged. Also . . . technology and pop culture exports . . . have brought New York and Paris cultures closer together. . . . "

But there does remain among many Parisians a formality—even a sometimes smug aloofness—that escapes most New Yorkers. An air of strictly formal courtesy that hinders casual friendship, much less intimacy. Americans who have lived there often recall the years in their Paris apartments when they rarely, if ever, interacted with their neighbors, even ones their own age. (God forbid: "Hey, how ya doin? See the game last night?")

During my prolonged trips to Paris decades ago I was aware of a discernible, if slight, thawing in the fabled Parisian ice. On my first trip, with my first wife, Chris, I kept my mouth pretty well shut, lest I piss off a white-aproned waiter in a café. I let Chris's high school and college French do the talking for us. Some years later—divorced and traveling solo—my French was no better (read: pretty much nonexistent) but there seemed to be a palpable increase in everyone's willingness to at least hear my stock tourist phrases without wincing. By the third trip—with Judy, whom I later would marry—it almost was fun to see if I could make myself understood, trying hard not to lard my French with too much Spanish or Italian.

I mentioned this to Neil, and suggested that I simply was becoming more familiar with Paris, and therefore more relaxed, with each successive trip. Maybe, Neil said, but he noted that he and Carol (who both speak excellent French) also had sensed a change in attitude and demeanor during their nearly decade-long French sojourn. Neil's theory was that their (and, by extension, my) Parisian experience had spanned a period when the center-right Gaullist government was succeed by progressively more liberal ones, and that this more liberal, or at least more global, attitude somehow had softened the often prickly Parisian attitude toward *l'etrangers*. (Or at least toward *etrangers* who looked like them.)

Attitude can be measured in many ways. Another difference is reflected in the way New Yorkers and Parisians eat and drink.

New York, remember, is where the hurried white-collar lunch was invented, in the victorious aftermath of World War II. That's when a booming postwar economy sparked the era of Madison Avenue, a car in every garage, supermarkets, TV dinners, the hurried coffee break, and commuter trains rushing to and from the burgeoning suburbs. As Paris, and the rest of western Europe, emerged from the rubble of a terrible war, a return to normalcy could be something as simple as the reopening of a favorite café, or the resumption of a town's daily market. "In France, we choose life over work," declared travel writer Carrie Dennis recently. "We choose strikes over work [too] but Americans work too much. . . ."

It should be remembered that there's a Horn and Hardart Automat wall in the Smithsonian now, though it's an historic relic, not a source of lunch. The Automat—the precursor of fast food—was doomed by the emergence in New York and other large American cities of *even faster* food: McDonald's, pizza joints, gourmet lunch trucks. And so the Automat, or at least a piece of it, is now entombed in the National Museum of American History.

Then there's cheese, or more precisely, the cheese *course*.

This just doesn't happen in the States, except perhaps at the toniest restaurants in New York and other big cities. Yet to my young and hungry eyes forty years ago, this

was a beautiful addition to every dinner when I first came to Paris, and later to my friends' quaint and tiny place in Bonnieux in the Luberon. And the cheese was room temperature: the Brie sensuously runny, the Roquefort pungent and blue-veined, all arranged elegantly on a platter—not rushed from the fridge—to be savored at the end of a meal with the last crusty bits of the baguette.

Another indicator: Want to grab a quick coffee in New York? Hit the Starbucks, probably on the very block you're standing on, and emerge minutes later, cardboard cup in hand.

Want the same in Paris? In most cases (nb: I said *most* cases) the fastest you can do this is to stand at the bar in a local tabac and have your café served in a china cup and saucer—a little metal spoon there on the side with which to cool your drink or stir in your sugar. Don't even think of wooden or, God forbid, plastic stirrers. In fact, this is the norm all over Europe. In the six years that my wife and I worked on our book on Venice, I don't know that we ever once saw a takeaway coffee cup.

Then there is the placement of café chairs. In Paris, the custom long had been to place outdoor café chairs facing the street or boulevard, the better for patrons to regard the passing parade at their leisure. And if at times it seemed difficult to get a waiter's attention, it simply might have reflected his willingness to let you sit and linger. Years later I noticed this also in Piazza San Marco in Venice, and in any number of other less-grand places throughout Italy.

Parisians back then (and even now to a large extent) were adept at *flânerie*: the art of aimless strolling or lounging. Not to make a career of it, certainly, but to enjoy the passing scene more easily than the average American and certainly the average New Yorker. (And not just Paris: In Barcelona for example, Las Ramblas, a pedestrian esplanade in the heart of the city, is made for such wandering, just as in Italy an evening *passeggiata*, arm-in-arm with a loved one, or even a friend, can be a daily ritual.)

Roger Cohen, writing in *The New York Times*, said of Paris: "This is a city of stolen moments, its romance tied to realism about the vagaries of the heart. Nothing surprises. Little is judged. In the realm of sex and coupling, a shrug of the shoulders is what you get from the French. Or as they would put it with dismissive bluntness: 'Bof.'

"Intimacy, for the French, is nobody else's business. A strong respect for privacy prevails. It is combined with reluctance to attach any moral baggage to people's love lives. The effect is liberating. France does sex and food with aplomb. Guilt is not really its thing."

BELLY UP TO THE BAR,
S'IL VOUS PLAIT

My late father, Al Van Riper, introduced me to a lot of things, among them baseball and English literature. As a young man in Flushing, New York, in the late 1920s and 30s he played first base on an American Legion baseball team, and decades later we spent many afternoons together at Yankee Stadium and Ebbets Field. Though he never went to college—having grown up during the Great Depression—he was an aspiring journalist and rabid reader who loved great writing, from Shakespeare to Hemingway. He passed that love on to his only son.

Another thing Pop introduced me to was McSorley's Ale House in Lower Manhattan, and in so doing, opened up for me the world of friendly shadows and sawdust on the floor. (*Baseball, books, and beer*—thanks, Pop.) That introduction informed my impression of bars and cafés around the country and later around the world. A case can be made, I think, that the Internet and digital technology have laid waste to what once had been congenial places to belly up and have a few quiet drinks, alone or with friends. Maybe a small black-and-white TV set at one end of the bar was OK, the sound low or turned off—except during, say, the World Series or a title fight. But today's average sports bar with multiple huge screens and blaring sound does not lend itself to savoring the pleasures of the grain or the grape.

Which is what made McSorley's so special.

It was a throwback even one hundred years ago, having been founded by Irish immigrant John McSorley around 1854 on the same spot it occupies now: 15 East 7th Street, near Cooper Union. By the time I got to be a semi-regular in the early 60s as a college student and would-be writer and photographer, the layer of dust was dense on the walls and on the scores of framed pictures that hung there. And, though for more than a century it barred women, McSorley's was a place that sneered at class distinction. Workman and bigwig were treated equally. I never forgot looking up from our table one evening—a table now cluttered with empty ale glasses—and seeing my CCNY philosophy professor Dr. Willard Hutcheon (natty in tweed jacket and vest) deep in conversation with a guy in greasy coveralls.

The place really did have (and does have today) sawdust on the floor, as well as a working potbelly stove. The only alcohol served was McSorley's specially brewed ale, light and dark, served two at a time. No hard liquor. The menu also was limited to a few items, including a cheddar and raw onion plate and a liverwurst and raw onion sandwich. Note the onion theme. For years McSorley's lived by these three phrases: "Be Good or Be Gone," attributed to John McSorley himself. "We

were here before you were born," and the simple boast: "Good Ale, Raw Onions . . . No Ladies."

That changed in 1970, when two attorneys for the National Organization for Women won a discrimination suit against the bar. Reluctantly, but politely, women were admitted, and the place did not fall to the ground. But accommodation did have to be made quickly over the restroom. Someone simply put a lock on the door of what previously had been the wide-open gents'. Sixteen years later women finally got their own toilet. (For now, McSorley's' only problem seems to be maintaining its sheen as a working-class bar—and not as a suddenly trendy hangout for striving millennials from Wall Street. It's even serving burgers and fries—bad sign.)

Working-class bars no doubt exist in every culture that welcomes alcohol, and everyone doubtless has fond memories of at least one favorite dive. Near 75 West Street in lower Manhattan—the old *New York Post* building, where I used to work as a copyboy in the 1960s—night shift copy editors and reporters would troop into one dump a few doors up from the paper as soon as the clock struck 8 a.m. and their shift ended. It was, after all, Miller Time to their body clocks, and the bar owner knew that. Similar bars existed in Paris near Les Halles, the huge (now gone) market where stalls of meat, produce, and fish were sold all night, and where, if one looked hard enough and knew whom to spot, Michelin-starred chefs could be seen in the pre-dawn, sniffing, feeling, and poking what would end up in their restaurants, and on their patrons' plates, just hours later.

Even the most unprepossessing French bar or café aspired to a certain sense of style, reflecting what one writer has called the "French dedication to life's refinements." Thus years ago it was easy to find even neighborhood places with zinc-topped bars, bentwood or wire chairs, and small marble-topped tables, on which one could nurse a small espresso, *citron presse*, or glass of respectable red. Of course a *citron presse* or *jus d'orange* often cost more than *vin rouge*. In fact, perhaps the most popular drink at the average local bar was a *ballon rouge*: a large glass of the bar's least distinguished, yet still drinkable red wine that some hardy folks would down in the morning on their way to work (and doubtless have one or two more on the way home).

Simple bars like these were gathering places for all ages. Many were *tabacs* where one also could buy cigarettes and lottery tickets. Many of the smaller older cafés back then also featured *toilettes turques*—Turkish toilets—that basically were one slippery step above a hole in the ground. When nature called you went into a stall, straddled two porcelain footprints next to the hole, and hoped you did not splash. It was the same for either sex, though during this period men had the dubious advantage of also being able to use pungent outdoor *pissoirs*—enclosed steel cubicles that were one step above peeing against a wall. They were introduced in Paris in the mid-1800s, and now thankfully have been replaced by high-tech unisex public toilets.

Another fixture in the back of Parisian tabacs and bars often would be a beat-up pinball machine: a magnet for young people, some so skilled that there would be a constant soundtrack, not of televised sports results from ESPN, but of beeps, bells, whistles, and *flip-flip-flips* generated by the best of these pinball wizards.

Today—*desole*—some bars and cafés, like the famed Les Deux Magots in Saint-Germain-des-Prés, long ago surrendered their charm and simply became tourist attractions, even if decades ago a young Ernest Hemingway could linger there over a drink undisturbed—even ignored—and write in his journal with a knife-sharpened pencil. More recently, writer Samuel Shimon wrote of seeing a friend at the Café de Cluny in the mid 80s, shortly after Shimon arrived in Paris. The friend "glanced up and said: 'Look at that man!' I turned round to the man sitting at the window overlooking boulevard Saint-Germain. 'Oh! It's Samuel Beckett' I exclaimed."

Today, bars, pubs, and cafés almost everywhere have had to toe the line and ban smoking—to some people one of the great accompaniments to beer, booze, wine, or coffee. In Montmartre, for example, Café des Deux Moulins, which drew fleeting fame as the location where much of the 2002 film *Amélie* was made, removed its tobacco counter, but was able to accommodate its larger tourist crowds by then adding more seating.

Still, Parisians love their cigarettes. "When Neil and I were there in 2010, not long after the [smoking ban] we were thrilled at the idea of not being surrounded by smoke," noted former ex-pat Carol Offen. "Except that in September, because of beautiful weather, everyone, including us, was on the sidewalk—where, of course, we were surrounded by smoke. (True, it was outdoors but it was still strong.) Also, I recall one of many cafés that had an opening between the *terrasse* and '"indoor"' tables at the front. Even though we were technically sitting in the no-smoking indoors, it was not much different from being in the smoking outdoors—except that we had ceilings holding in the smoke."

Parisian cafés, like most of their European counterparts, differ from most American bars by the simple variety of their fare. Thus, the same bar where one can enjoy a quick beer or cognac on the way home from work also can accommodate a teenager looking for a *croque monsieur* or a *grandmère* and her granddaughter hoping for a cup of *glacé* or *chocolat chaud*.

Provided, that is, that they can pronounce it properly.

In *Paris Was Ours*, a collection of writers' reminiscences on Paris edited by Penelope Rowlands, she recalls the familiar humiliation that Parisians, especially Parisian waiters, can inflict.

"The waiter, for example, who refused to bring me a hard-boiled egg—the classic French worker's breakfast—in a café because I couldn't pronounce the malevolent

short *u* that sits dead center in the word *dur*, meaning 'hard.' He was unabashedly gleeful as he made me repeat it, shrugging his shoulders, delightedly, in faux incomprehension each time. The more I stumbled, the happier he became. I settled for a croissant instead."

In New York, there's a word for guys like him: *schmuck*. (No short *u*.)

ROOT CANAL IN PARIS

I knew I should have had that tooth looked at before I went to Paris.

It was 1980, I was living single again, and figured that as long as I kept picking food out of the hole in my molar, I'd be fine.

I had arrived the previous day at Neil and Carol's place on the Rue de Malte, a working-class district near the Place de la République, after what may have been the best transatlantic flight of my life. The plane was maybe half full and I shared the middle five seats with one other guy who worked for the State Department. We struck up a conversation and talked through the night, fortified by cognac that the flight attendants were more than happy to pour, if only to pass the time.

It was the only time I ever landed in Europe without jet lag.

All was terrific until the next night, when a searing pain woke me before dawn: my rotten tooth finally had exposed a nerve. Miraculously, Carol had a dentist's appointment that morning and said she would see if the dentist could fit me in.

Dr. Huth, bless him, could and so began my Parisian odyssey into oral surgery.

We arrived at the office on what had turned into a spectacular morning: deep blue skies and cotton ball clouds. Even with my pulsating tooth, I marveled at how beautiful Paris looked that morning, especially there, on the Right Bank, as we approached what in Manhattan might have been compared to an elegant brownstone, though, in truth, this six-story "building of grand standing" was a clear cut above.

Walking up the stairs to the dental office, I was surprised to see that the frosted windows that lit our way were, in fact, sculptural panes of Lalique glass. The dental office turned out to be a huge apartment suite, the waiting room elegantly furnished and hung with bright floral wallpaper.

But that's not what caught my eye. In one corner I seem to recall a pinball machine or some other oddity—there, one assumes, as a ready-made sculpture, not as a pastime for patients. And the floral walls were hung with dozens of signed framed photos from prominent clients in show business and sports. Memory fails, so it's possible that that was *not* a grateful Charles Aznavour hanging on the wall. But it *was* clear that Dr. Huth and Madame Huth, his wife and partner, were dentists to the stars.

After a while, I was ushered in to another lovely room—this one with a dentist's chair—and Madame Huth, an elegant woman in her forties with a gentle manner and even gentler hands, gazed into my mouth.

There was no alternative: I needed a root canal.

That I recall the procedure with such equanimity simply reflects the fact that it was all so quick and comparatively painless. Madame Huth injected me with novocaine

and afterwards, all that I remembered were her skilled movements with drill, pick, and amalgam.

A short while later Carol and I were out the door, my Paris vacation saved.

A week later, I returned to the office for a checkup and this time I met with Dr. Huth at his desk. He was delighted I was pain-free and, when I asked how much I owed him, he thought for a second and then, waving his hand, came up with a figure that seemed way too low.

On my return to the States, I did a Sunday piece for the *Daily News* about my adventure. As I recall, the fee I got for the piece pretty much covered the cost of the root canal.

HOT TYPE

It once seemed to take a million moving parts to put out a newspaper—a real printed-on-paper edition of, say, *The New York Times*, the *Herald Tribune*, or *Le Monde*.

It was an overwhelmingly analog and artisanal process, born of great machines, hot metal, and great skill—not to mention thousands upon thousands of words and hundreds upon hundreds of photographs. The two groups that put all this together—the craft people and the editorial people—worked together harmoniously for the most part, provided one did not invade the other's turf, most notably in the composing room. To newspeople of the time it was widely and proudly held that they produced the equivalent of a small novel *every single day*—and all with technology that barely had changed since the invention of the rotary press.

I formally entered the news business in June 1967, one week out of CCNY, as an editorial trainee for the New York *Daily News*—having previously run copy and news-clerked on the *New York Post* and the old *Herald Tribune*. The *Post* job was a one-night-a-week affair while I was in school. I worked the lobster shift from 1 a.m. to 8 a.m. on Saturday morning with a couple of other copyboys, catering to the needs of a small group of reporters and editors who put out the first edition of that p.m. paper from a decrepit city room on 75 West St., at the foot of Manhattan.

Ed James, a mordant—and morbidly obese—black guy was the head of nightside copyboys. Ed also manned the switchboard in the center of the city room, where he sat on a rickety chair like a dark Buddha. Like everything else at the *Post*, the switchboard was a relic from the "Front Page"—all wiry cables and jacks, that Ed deftly plugged in each time he had to direct a phone call to someone's desk.

Among other things, Ed taught us how to monitor the clattering AP, UPI, and other wire-service teletypes just off the city room. At regular intervals through the night, we would tear the stories from the machines and place them before Bob Spitzler, the night city editor. He, in turn, would read them and either spike them or hand them to reporters or rewrite men to fashion into stories for the first edition. (It seems odd today, but back then all that the reporters and editors had in front of them [besides ashtrays filled to overflowing] were manual typewriters—not Internet-wired computers, black rotary phones—not smartphones tethered to the universe. News from the outside world came only from what they heard on the telephone, the police scanner, or from what we gave them from the wire room. This was before 24/7 cable TV—CNN, C-Span—any cable TV for that matter. Even if there were a TV in the newsroom [there wasn't] all you'd get at that hour would have been test patterns or maybe a black-and-white horror film.)

But keeping everyone abreast of breaking events was just part of our job. In fact our

most important job was the 2 a.m. and 7 a.m. food order. One of us would go around to everyone in the city room, asking what he (or occasionally she) wanted from the one-arm joint downstairs that everyone called "the Greek's." The 2 a.m. was fairly easy—mostly coffee and Danish, maybe a bagel. The 7 a.m. was more elaborate: eggs and bacon, sandwiches, etc. It took a while for the order to be cooked up, so the deal was that the copyboy could eat breakfast free as he waited in the diner.

One morning as I was scarfing down my free bacon and eggs, I saw from the corner of my eye what I thought was a fairly good-sized cat scurrying across the door of the Greek's storeroom.

It wasn't a cat.

In the 1960s, manual typewriters, rotary landline phones, greasy black copy pencils, and hot metal type were the building blocks of newspapering, and if some of the building blocks—the typewriters and the telephones, for example—were succeeded by computerized or digital replacements used by a new generation of reporters and editors, the other building blocks simply vanished in the new digital technology.

And along with them the thousands of craft union jobs they once supported.

I already had inhaled the tangy smell of printer's ink some years earlier editing my college newspaper and working late into the night in the tiny printing shop that we used in lower Manhattan. There, we callow newsies from CCNY worked side by side with a handful of journeymen printers in a Dickensian printing shop, first on East 4th St., later on 22nd St., where the printers let us use the Ludlow machine to hand-set headlines and where we routinely handled type with them on makeup. It was only after I had joined the big dailies that I learned the hard rules of newspaper apartheid.

In that rigid world, no one—*no one*—except members of the printer's union could lay so much as a finger on type as the next day's paper was being made up in the composing room. To do so would risk a wildcat chapel meeting in which every printer would stop work and go to a room just off the composing room floor until management expressed sufficient contrition for the outrage.

But it could have been worse. Legendary newsman and editor Jim Bellows once touched the type one time too often in the composing room of the *Detroit Free Press* and somehow a whole page form was "pied"—dropped into hundreds of pieces onto the composing room floor as the edition deadline loomed. Bellows learned his lesson.

Certainly the union rules reflected a stubborn pride in one's designated job, but also, I think, it reflected a town and gown tension between largely college-educated editorial people and their blue-collar craft union colleagues (even if printers routinely earned more than many reporters and editors).

And if union rules in the US seemed rigid, in Europe they were even more so.

"I remember once we accidentally left off a photo credit for a photographer and he had the right to something like a 1,000 franc 'indemnity' because we had broken the rules of the agreement with the photographers union. And that was real money back then," said Neil Offen, who in the early 1980s edited an English-language weekly in Paris.

"Another thing about unions in France, and this is the stuff [President] Macron is working on now and the unions are resisting: it used to be that you got six weeks of vacation *from the moment you started* [a job]. That meant, say, you could work a week and then take six paid weeks off."

None of that mattered to me back then as I pinched myself realizing that I actually was working in a big city newsroom. The *Post*'s was a dump, to be sure, but there I was taking Pete Hamill's dictation from Selma, Alabama, as he covered the violent turmoil of the 1960s civil rights movement. Over at the *Herald Tribune*, the city room was cavernous but it had a boatload of talent to fill it, not least including Jimmy Breslin and Tom Wolfe.

You couldn't ask for more visual contrast: Jimmy always looked like an unmade bed; Tom always wore an immaculate white suit. Yet each redefined what it was to be a reporter. Each wrote lyrically and in depth about people. Each was simply eloquent. I wanted to be like them.

Years later, when I was in the New York *Daily News* Washington bureau, Jimmy joined the paper, jumping from *Newsday*. I remember watching him in action at the Democratic National Convention in '68, sticking to his sources like glue and following them until he got the story no one else had. In 1978, I was sent to coal country to cover a nationwide coal strike that seriously threatened the nation's economy. Having no way to cover it as a spot news story, I covered it the way I thought Jimmy Breslin might: doing feature stories on individuals and larding my copy with lots and lots of color. It was some of the best stuff I ever did. But what I remember most is Jimmy calling me from New York early every morning (he got the name of whatever motel I was staying in from the telegraph desk) and asking whether he should come down.

"Sure, Jimmy," I said, "there's plenty of stuff to go around."

"Nah," he would say, "your stuff is too good."

Jimmy never came.

In 1986, Breslin finally won the Pulitzer. I sent him a note congratulating him, and said I always would be proud of the fact that I kept Jimmy Breslin out of coal country.

When people asked about my twenty years on the paper, I said I would have paid the *Daily News* to write there—and I was not alone. Pete Hamill, who once wrote a thrice-weekly column for us, and later became editor-in-chief, put it best. "Writing for the *Daily News*," he said, "was like playing for the Basie band."

SUBWAY: THE BRONX IS UP; SO IS THE GARE DU NORD

To ride the D train back then all you needed was fifteen cents and a high tolerance for noise.

The D train (starting in the north Bronx and ending at Coney Island in Brooklyn) was just one of many New York City subway routes. The A train was probably best known, thanks to Billy Strayhorn's jazz standard "Take the 'A' Train" that Duke Ellington made the signature tune for his orchestra in the 1940s.

But those were just two of more than two dozen subway routes crisscrossing the five boroughs in such a remarkable grid pattern that anyone could get anywhere in the city—save perhaps for the outer reaches of Red Hook in Brooklyn or West Farms Square in the Bronx—for the same lousy fifteen cents.

As it happens, both the New York and Paris subways are about the same age. New York's, the largest rapid transit system in the world in terms of stations—roughly 472—dates back to 1904. The Paris Metro (short for *Métropolitain*) began operation four years earlier, in 1900, and today is the second busiest subway system in Europe, after the Moscow Metro. Still, Paris' number of in-city stations (245) is dwarfed by New York's. (Nb: the term "Métro" now has become a default name for virtually all modern subway systems, from Toronto to Washington, DC. But the oldest subway in America—Boston's—simply is referred to as "the T," for Metropolitan *Transit* Authority.)

Fifteen cents a ride was the fare I knew best when I lived in the Bronx. The basic New York City subway fare was fifteen cents from 1953 to 1966 (today it's $2.75)—the longest time without a fare hike since the subway first opened. If you were lucky and it wasn't rush hour, your fifteen cents let you sit on woven straw seats or, failing that, hang onto spring-loaded steel handles that hung from the ceiling, or failing even that, grab on to a floor-to-ceiling pole, one of many that punctuated every subway car.

In postwar New York and into the mid 60s, the New York subway was a fast, convenient way to get from point A to point B, even if it was layered in grime. And you traveled in relative safety.

The Paris Métro of the 1980s was an odd mix of the old and new. The most obvious retro *nonpareils* were the Hector Guimard–designed Art Nouveau subway entrances—simply glorious evocations of the natural world writ large in steel and glass. (One such relic now graces the courtyard of the Museum of Modern Art in New York.) Descend into the Louvre station, or Gare du Nord, or Sèvres-Babylone or anywhere on the system and you could see gleaming steel subway cars juxtaposed with dingier ones that seemed to come from New York, or even the previous century. The older ones did have more

élan—especially the ones on rubber tires. More important, none of the cars was marred by the graffiti that for a while became the signature look of underground New York.

The Paris system also was built on a smaller scale, in that many stations—with their severely curved walls—somehow seemed more intimate. Maybe it was the hugeness of the posters that made one feel small. I recall a gargantuan poached trout on a poster maybe ten feet wide that promoted Benedicta mayonnaise. Too, in that largely pre-computer/pre-digital era, what passed for high-tech direction-finding were large station-mounted electronic maps on which scores of tiny individual light bulbs lined each in-town route.

Confused about how to get somewhere? Simply push the button for point A with one finger, point B with the other. *Et voilà!*—scores of little bulbs would light up the most direct route for you. I always thought of pinball machines when I did this.

From the 1920s to the 70s another, though little-lamented, feature of Paris stations were *portillons automatiques*: automatic crowd control gates that closed off the platform when trains were in the station, to keep crowds manageable and safe, especially during rush hour. Fine, except if you were racing to make a train and were blocked out. In that case, it was maddening. Most were dismantled by the mid to late 70s.

In post–World War II New York, there was no such thing as air conditioning in the subway—this was the era when people would sleep on their fire escapes in the summer or go to the movies just to get cool. So in the steaming summertime subway, huge fans tried without success to move the air, several mounted on the ceiling of every car, just a foot or so above your head. The fans' wide metal blades moved as fast as airplane propellers and, in the older cars, were just as unprotected. Nobody messed with them.

Newspaper stands, once the lifeblood of sidewalk life in any big city, proliferated underground in New York as well. Run by the Union News Company, these stands dotted the bigger stations and were every bit as full as their aboveground counterparts, hawking papers, magazines, cigarettes, candy, and gum. Vending machines also could be seen on many stations' steel columns, though I swear I never saw anyone use them.

That all changed beginning in the late 60s.

During that time, the New York subway underwent a terrible metamorphosis. Blame it on urban decay, social upheaval, lax policing, the political ineptness of two-term mayor John V. Lindsay. Whatever the cause, the proud New York City subway became, in the words of Magnum photographer Bruce Davidson, a place of "grim, abusive, and violent reality."

It looked awful—like the bowels of hell. Every interior inch of almost every subway car, especially the newer ones with shinier surfaces, was covered with hideous, crudely scrawled graffiti—don't even try to call it artistic expression. Train exteriors, too, often bore the mark of vandals who roamed the subway yards at night.

Thugs preyed on passengers—to the extent that undercover cops had to prowl

high-crime stations—and a private group of scowling protectors, the Guardian Angels, took to patrolling subway cars in white T-shirts and red berets.

By contrast, Parisian subways were fairly tranquil, though in the 80s there was talk that subway crime there had "quadrupled." But even then, the crime rate was one-eighth of what it was in New York.

(It should be noted, that safe and elegant though the Paris subway was in the central city, stations in the outer arrondissements, where poor immigrants lived, were far rougher, suffering the presence of beggars, pickpockets, and graffiti.)

And, said ex-pats Neil and Carol Offen, "We remember so many times, getting off the Métro at a big station, say Concorde, walking up the steps and seeing obvious-looking immigrants—Arabs or black Africans—being asked for their papers, to check their identities. In all the years we lived in Paris, we were never checked. But we were white."

Subway violence in New York became the fare of TV and movies. I remember as a cub reporter on the *Daily News* in the late 60s, covering the making of a movie called *The Incident* about two young toughs terrorizing an IRT subway car full of passengers. The film was not shot on location, but in the old Biograph Studios in the Bronx. There, a full-size, largely wooden replica of an IRT subway car dominated the soundstage—its rumbling movement achieved by stagehands alternately moving huge wooden beams levered under the car out of camera range. The two young toughs in the film were played by then-unknown actors Tony Musante and Martin Sheen.

Perhaps the best-known subway movie of the era was the 1974 film *The Taking of Pelham One Two Three*, after the novel of the same name by Morton Freedgood (writing under the pseudonym John Godey) about a gang of men who take late-night subway passengers hostage for a million-dollar ransom. The bad guys lose, to a wonderfully laconic transit police lieutenant played by Walter Matthau, but not before we hear one of the best cynical New Yorker lines ever uttered in a movie. (Nb: by this time the subway fare had risen.)

Amid the agonizingly tense negotiations between the hijackers and the transit police, a frazzled dispatcher shouts, "Screw the goddamn passengers! What the hell did they expect for their lousy thirty-five cents—to live forever?!"

CHAMPS-ÉLYSÉES OF THE BRONX

For decades it was the best address in the Bronx, on the most elegant of boulevards. It was where striving postwar families—mostly Jews, but Italians and Irish too—put down roots to seek the American Dream. Fittingly, you'd have to walk up to it from either side.

On the west side at 161st St., for example, go up from Yankee Stadium, past Joyce Kilmer Park and the tomb-like Bronx County Courthouse, and you'd be within sight of the grand hotel that housed the New York Yankees. From the more residential east side, at East 166th St. where I lived, you'd walk up from the Needle brothers' tiny grocery store, with its pickle barrel and hand-cut cream cheese and halvah, past Drazen the tailor, Forte the cobbler, and Trotsky the druggist, and after one level block finally reach it: The Grand Boulevard and Concourse—the Grand Concourse—the "Champs-Élysées of the Bronx."

In fact, the Concourse is almost four times as long as the great Parisian thoroughfare (4.5 miles versus 1.2) and though it cannot boast an Arc de Triomphe it featured some of the most beautiful Art Deco buildings outside of Miami Beach, as well as Art Moderne, Beaux-Arts, and Tudor buildings rivaling any in the city. Tree-lined islands dotted its eleven lanes and in the north, near Fordham Road, there was the 3,800-seat Italian Baroque Loew's Paradise Theatre, once the largest movie palace in all of New York, including Manhattan. The theater opened in 1929, as part of a chain of Loew's Wonder Theatres, and featured among its over-the-top attractions a glowing evening sky and twinkling stars. (After its glory years, and a period of steep decline, the Paradise wound up cobbled into a multiplex, turned into a night club, then leased to a black evangelical church.)

The "Park Avenue of the middle class" begins unprepossessingly in upper Manhattan and ends almost as humbly at the north Bronx's Moshulu Parkway. But in between, apartment buildings—elegant by Bronx standards, modest measured against Midtown—dotted each side of the street in the city of my childhood. They created in my memory a beautiful backdrop for long walks with my father down the Concourse's elegant straightaway, especially in the fall, when the trees were vibrant and the air was crisp. The Fish Building was to me the best example of what made the Concourse special. At 1150 Grand Concourse, the entire exterior entranceway of this Art Deco apartment building was adorned by a fantasy of tropical fish and plants, all done in tiny, shiny mosaic tiles. The lobby of the building, too, offered elegant terrazzo floors and clean Art Deco lines. Other buildings along the boulevard offered the stolid seriousness of red brick, but often punctuated by ornate forecourts and pathways that consciously echoed impressive residential buildings in London, Paris, and Berlin.

One of the largest buildings on the Concourse was the Concourse Plaza Hotel. It dominated a whole corner and created for generations what doubtless was viewed as Manhattan-grade elegance in the Bronx. How elegant? I remember attending a friend's bar mitzvah there and, though awed by the hotel's grand ballroom, I think I was more impressed—even at age thirteen—that Freddie Rappoport's parents had sprung for a stand-up comic to entertain guests during the pre-dinner cocktail hour, as if we all were lounging at the Stork Club in Manhattan.

The hotel's other claim to fame was its proximity to Yankee Stadium, only blocks away on River Avenue. It was so close that until the 1950s the Yankees maintained a block of apartments for its own and visiting baseball players, including Hall of Fame slugger Mickey Mantle. The insular, entitled world of super-stardom didn't exist then, so it was not uncommon to see sports stars in public. (Roger Kahn's book about the 1950s-era Brooklyn Dodgers, *The Boys of Summer*, for example, features a wonderful photo of Brooklyn right fielder Carl Furillo stopping on his way home from a day game to pick up milk and groceries.)

But my most vivid Yankee memory was relayed to me by my father (or was it my uncle Charlie?) and it involved a drunken summertime foot race along the Grand Concourse by a gaggle of Yankee superstars, all in suits and ties.

As relayed to me shortly after it happened, a group of Yankees, led by second baseman and champion hell-raiser Billy Martin, tumbled one evening from the Concourse Plaza bar onto the sidewalk to see who was fleeter of foot. All were dressed, more or less, in business clothes and street shoes. Besides Martin, the group included Mantle and perhaps pitcher Whitey Ford. They set up shoulder-to-shoulder and at the count of three took off up the street—toward my father (or my uncle).

God knows who won the race but who would not have been impressed by three base-ball legends, happily drunk and barreling toward you, under a starry Bronx sky?

OF BICYCLES AND BASEBALL

In Paris every summer one of the world's great international sporting events, the Tour de France bicycle race, ends in a festive dash down the Champs-Élysées as thousands of onlookers cheer and applaud.

In New York every fall, for more years that most people think is even remotely fair, baseball's greatest competition, the World Series, has ended in delirium in the Bronx as the New York Yankees brought yet another championship home to Yankee Stadium.

These two great competitions, so different in style and content, share a common birth date. Each began in 1903 and each bestows upon its champion the title of world's best.

My acquaintance with the Tour de France is slight. Forty years ago I was on the Champs-Élysées as the race finished and was barely able to see the heads of the (then) cotton-capped racers—much less winning cyclist Bernard Thévenet—through the humanity in front of me as the cyclists raced around the Arc de Triomphe, sprinting to the finish line. (Helpful Parisian entrepreneurs hawked cardboard periscopes to help folks see over the heads in front of them.)

Baseball, however, was something I knew from the start. I loved it; I played it. And, as a New York kid living just blocks from Yankee Stadium, I watched a lot of it. I grew up with the Yankees of the 50s and 60s—the Mantle and Berra years— when the Bronx Bombers earned their nickname as they dominated the American League. (The team far and away is the best in baseball, having earned an astonishing twenty-seven World Series titles through 2017, including a record five consecutive championships, from 1949 through '53. As if to rub it in, they also hold the record for second most consecutive World Series wins: four in a row from 1936–39. By contrast, the club with the second best World Series record—the St. Louis Cardinals—has won only eleven titles.)

In that much smaller world of my youth it was not unusual to see one's heroes on the street. Our church, St. Angela's in the Bronx, was not far from the Stadium and on Sundays when the Yankees were playing at home I recall seeing the great rightfielder Hank Bauer and all-star infielder Gil McDougald attending mass there.

Though I remain to this day a fervent Yankee fan, as a kid I also I rooted for the then–Brooklyn Dodgers in the National League. Why? Because my father during World War II was in the same 77th Infantry Division as the great Dodger rightfielder Carl Furillo and so returned after the war with a soft spot for the Brooklyn Bums.

When I was born in '46 I inherited this fondness. Growing up in a city blessed with uncommon baseball riches—the Yanks in the American League, the Dodgers and the Willie Mays–era NY Giants in the National League—it seemed preordained that the Yankees and Dodgers would play each other in the World Series, and that the Yankees

would win. That's pretty much how it went until 1955 when the Bums finally beat the Bombers in seven thrilling games for their first-ever World Series title. On October 5, 1955, the day after the Dodgers' victory, the front page of the New York *Daily News* featured a huge Leo O'Melia cartoon of the gap-mouthed Brooklyn mascot hollering "Who's a Bum!" (The borough's joy was shortlived, though, since two years later Dodger owner Walter O'Malley moved his team to L.A.)

On the other side of the pond, the Tour de France easily rivaled Le Foot (soccer) as the biggest sporting event in the world for France even if its riders—with some notable exceptions—never did dominate the sport. In fact for the sports-minded French the Tour de France simply ruled daily life for three weeks every summer as riders arduously pedaled through its various stages, up and down mountains, across international borders, in a Herculean test of endurance and strategy. A friend who lived in France many years ago recalled "getting a haircut in a barbershop and the Tour was on the radio like a baseball game would have been in the States—it was the background music of the season."

This called to mind my own early years in Washington on the New York *Daily News*, when the Yankees were regularly in the World Series and games were played during the day. We knew it would take nothing less than a declaration of war to get more than a few inches of Washington bureau copy into the next day's paper, so we happily wrote short and passed the rest of the afternoon like most of our readers in New York watching the game in the office on a portable TV.

Of the scores of French cyclists who knew even modest Tour de France glory, one of the most revered was Jacques Anquetil, an elegant, relentless rider who, like the Yankees in baseball, became the first ever to win five Tour de France titles (four of them consecutively, from '61 to '64). Not surprisingly, his fame spread to the French ex-pat community in the US, as a friend and former colleague found out to his chagrin.

In the early 70's—shortly after Anquetil had retired from competitive racing—my friend took his then-wife to an elegant French restaurant in downtown Washington. Approaching the entrance, Jeff was surprised to see the restaurant's chef as well as the maître d' eagerly waiting to greet him as they arrived. Within minutes it became clear what had happened. The French speaker who had taken Jeff's reservation over the phone had misheard the name "Jeff Antevil" as "Jacques Anquetil," and for one brief shining moment Jeff was bicycle rock star.

Despite the mix-up, Jeff told me, dinner was wonderful.

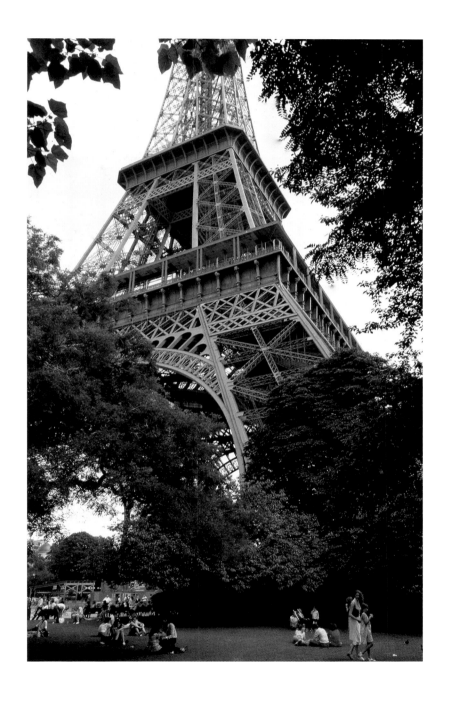

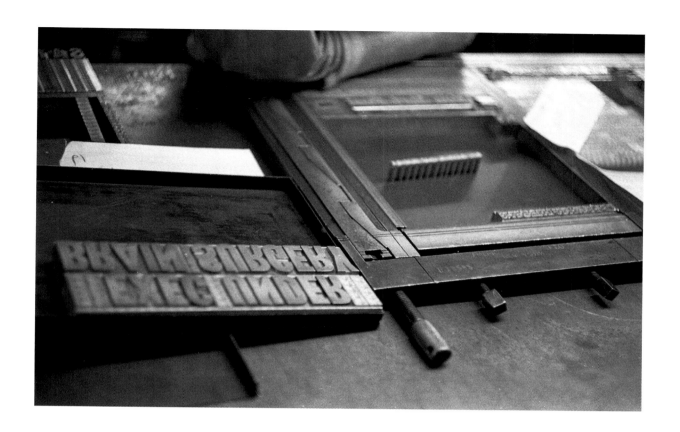

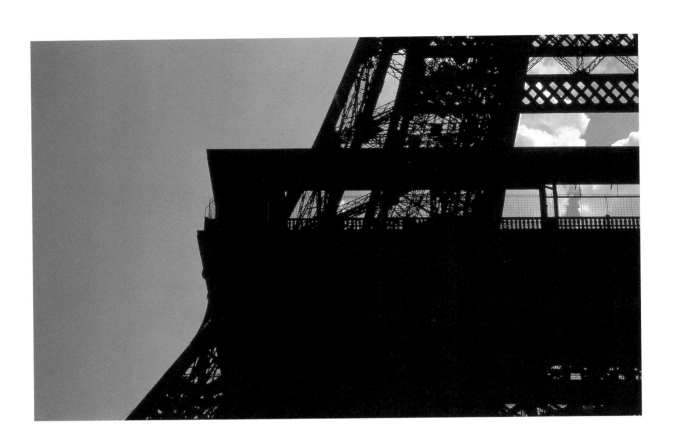

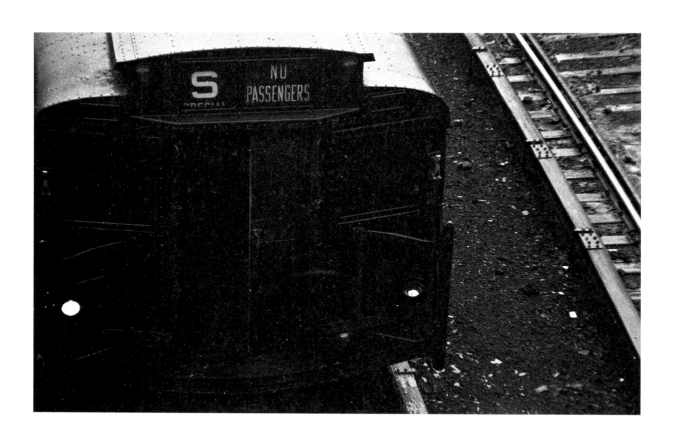

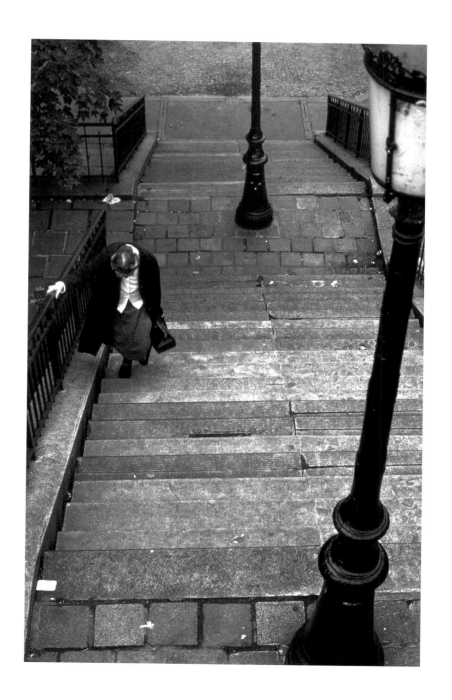

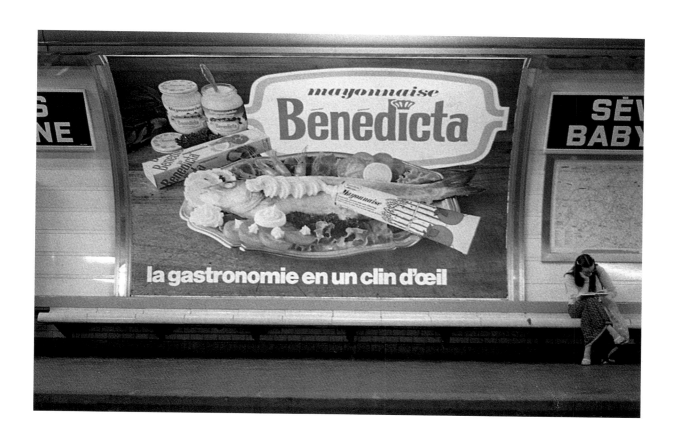

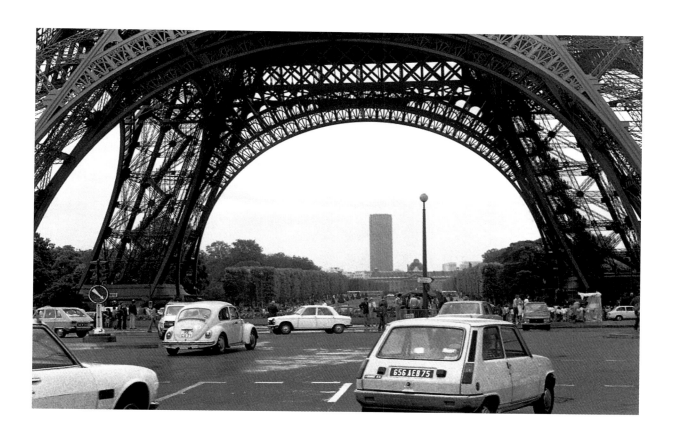

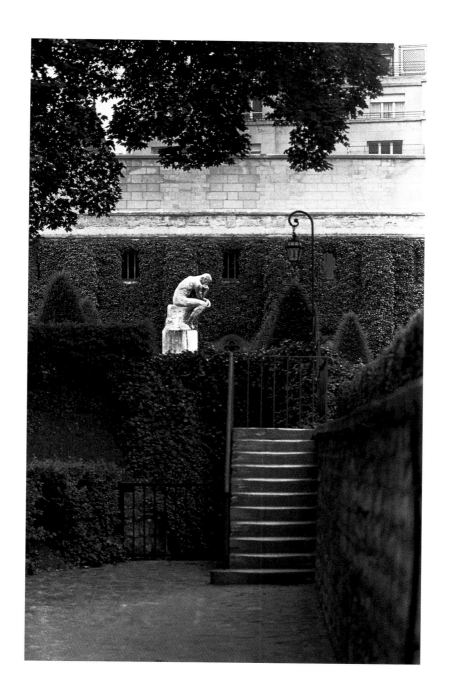

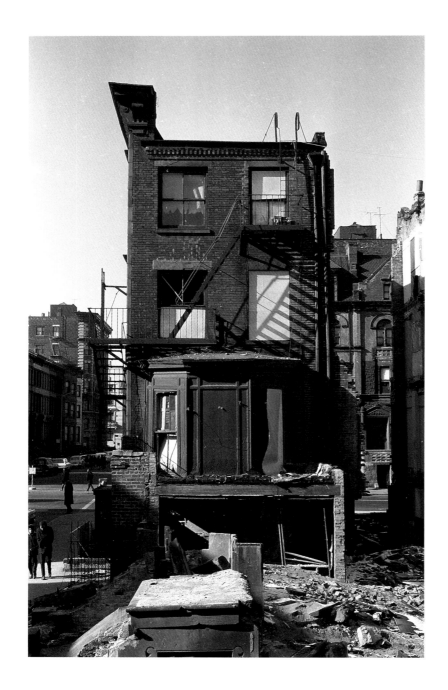

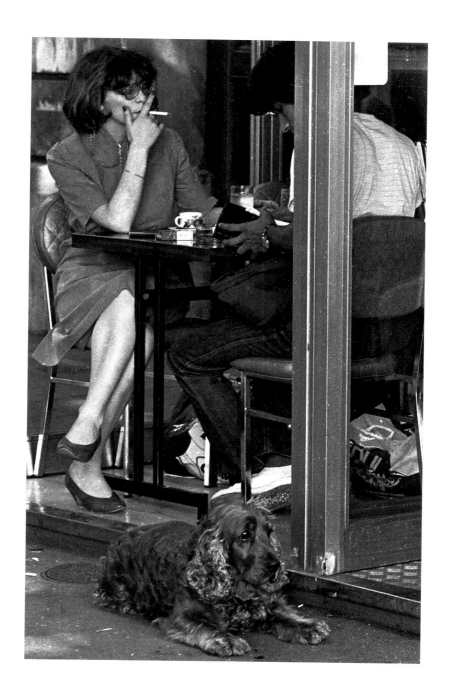

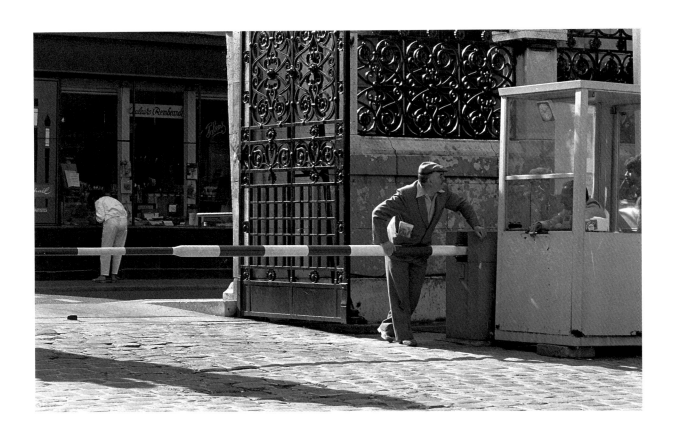

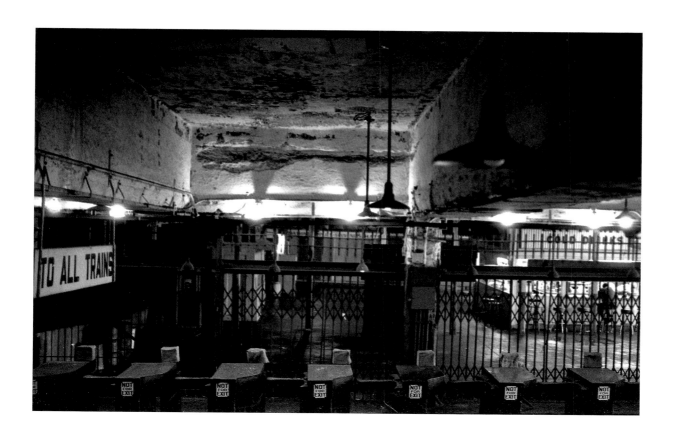

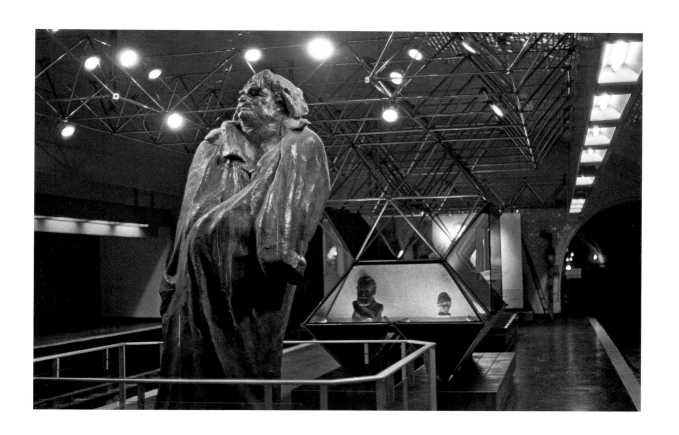

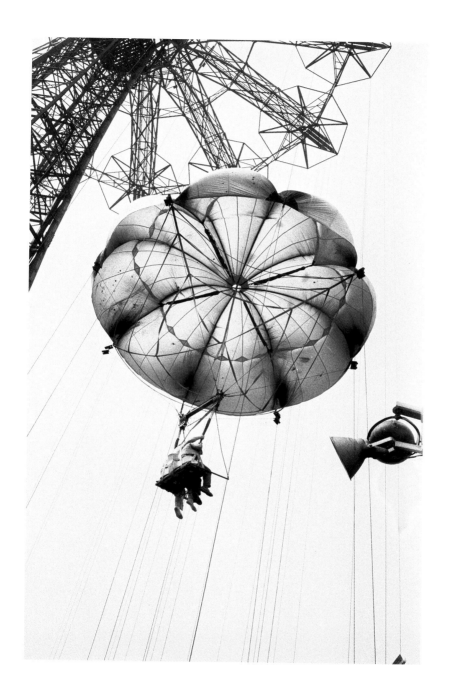

CONEY ISLAND, THE MYTHICAL BEACH, AND BROOKLYN'S EIFFEL TOWER

New York City can conjure up many things to many people, but sand probably is not one of them.

Skyscrapers, the subway, the Stadium (Yankee or Shea—sorry, CitiField)—even the slums—but rarely a beach, or, for that matter, the ocean, even though Manhattan is an island, not to mention Staten Island and Long Island.

Which then raises the question of Coney Island in Brooklyn, actually a peninsula that proudly boasts one of the longest boardwalks in the world, a nearly three-mile long free and public beach, the oldest wooden roller coaster in America, the invention of the hot dog, and, of course, the Coney Island parachute jump, also known as Brooklyn's Eiffel Tower.

Though we did not have a car when I grew up in New York in the 1950s and 60s, it was a cinch for me to get from the top of the Bronx all the way down to Coney Island at the tip of Brooklyn on the subway. And all for fifteen cents. And I didn't have to change trains. The D train went from the north Bronx at 205th St., through Manhattan, and ended at the Coney Island station, within steps of the boardwalk.

The very words "Coney Island," written on every D train car, conjured for me sweet smells and excitement even in the dead of winter. (Who was Coney? What are Coney? The consensus seem to be that Coney refers to the Dutch word for "rabbit"—*konjin* [cf: "conejo" in Spanish; "coniglio" in Italian] and the fact that, during the time of Dutch settlement, the area was full of them.)

For someone who grew up carless in the Bronx, I actually had my pick of beaches and amusement parks. With aunts and cousins in New Jersey, my parents and I would spend every summer (or at least the two weeks Pop had off from his job as a note teller) at Asbury Park. This was the same place where, in the 70s, a hungry kid named Springsteen lit up the crowds at the Stone Pony, a dive bar within sight of the boardwalk and where decades earlier my father and I would eat Taylor Pork Roll sandwiches, enjoy kick-ass Italian lemon ice, and hit baseballs in the boardwalk batting cage.

My other New York area "beach" was Palisades Park, New Jersey, a short bus ride across the Hudson. Here, though, the beach was bogus: basically a large sandbox for adults and kids ringing a huge saltwater swimming pool. Palisades also had a lock on the best lemonade I ever tasted: start with dozens of plastic glasses, each with a whole lemon halved and squeezed. Add ice and lots of sugar, then fill every glass from a garden hose. Sell for twenty-five cents. Bliss.

In fact, the Palisades Park swimming setup mimicked another smaller pool that I loved as kid. It was in the Bronx, near the Jerome Avenue subway, and like Palisades, it featured a man-made sand "beach" and a respectable-sized swimming pool—only it all sat incongruously atop a corner brick building that housed changing rooms, lockers, and showers.

Still, for sheer number of attractions, Coney Island had all of them beat. And it had the parachute jump.

The parachute jump has been a Brooklyn and, by extension, New York icon almost from the time it debuted some eighty years ago. The famous thrill ride first started scaring the wits out of people in Queens at the 1939 World's Fair, then was moved to Coney Island in 1941. It should not surprise, given its birth in the years surrounding World War II, that the ride actually was developed as a way to train paratroopers. And, in fact, a less elegant version of the 250-foot, twelve-story parachute tower was used at a military training facility in the mid 30s—developed in part by the husband of aviation pioneer Amelia Earhart.

My first encounter with it was in the early 1960s and that also was when I made my best photo: looking up at the billowing parachute, fully extended, as a pair of riders, their legs dangling as if they were rag dolls, floated quickly to the ground and a bed of heavyweight springs that would cushion their fall. In the picture, the parachute appears as a graceful circle against the filigree of the parachute tower and a perfectly cloudless sky. Everything about the image speaks of ethereal floating—but that all changed when you bounced hard on the springs and tried not to bite off your tongue.

Fun, right? I confess: In all the times I went to Coney with my camera and shot the parachute jump, I never got up the nerve to ride it.

In *Brooklyn Gang*, Bruce Davidson's book of gritty photojournalism documenting teenage toughs in what seems now to have been a very innocent age, his images of duck-tailed teens preening in front of cigarette-machine mirrors, or couples intertwined in parked cars, called to mind all that was tantalizing and forbidden about Coney Island. Coney was where you went for yeasty excitement, be it on the rides or, as the Drifters sang, "under the boardwalk." I would go there photographing with my high school friend Morty, shooting in all seasons. Perhaps there was something liberating in the salt air that made it easier for me, as a fledgling street shooter, to take pictures of people, lost as they were in their own thoughts and experiences. I remember one time making what I thought were arty pictures of ocean-washed driftwood, then graduating to making closeup photos of a drunk asleep on the sand.

One year, Morty had an idea for our high school yearbook for a full-page photo depicting an idealistic youth looking into the bright future from the shore. I was to play the idealistic youth, standing on a shoreline looking into the noonday sun.

Morty chose Coney Island—the closest we could get to a shoreline on the D train—and, since it was winter when we did this, we would be assured of a vacant beach. I had to look the part so I wore my good overcoat and shiny new shell cordovan shoes as Morty looked down through the viewfinder of his Rolleiflex, urging me to move closer to the waterline.

Morty kept shooting and, after a while, I turned to yell, asking if he was through. That's when a low, freezing, wave hit me, soaking me up to my ankles and ruining my new shoes.

But the yearbook picture looked wonderful.

When I got off the D train I didn't head first to the water or the parachute drop. I always felt that the subway ended at the entrance to Nathan's hot dog stand since that's where I'd make a beeline every time I arrived. And who could blame me? Here, after all, were arguably the best franks on the planet: all beef, laden with pungent spices and garlic, slathered with spicy brown mustard, on a long bun. Only Hebrew National hot dogs rivaled them, and no trip to Coney would be complete without my downing at least two as soon as I got off the subway. One could be forgiven for assuming that Nathan's invented the hot dog and defined the genre.

But it didn't. In fact Nathan's hotdogs were the interlopers. Preceding them—way back in 1867—were what came to be known as "Coney Island Red Hots." These were sausages served in what then were novel, specially made tubular buns, introduced by Charles Feltman, an entrepreneurial German immigrant who previously had been selling pies from a pushcart.

Feltman and his Red Hots were an immediate success—he never called them "hot dogs" lest anyone think his inexpensive treats actually were part canine. Around the 1920s, a Feltman employee, Nathan Handwerker, began selling his own Coney Island franks in a long bun at half the price. When Feltman's business tanked in the Great Depression, Nathan had the field to himself.

With its beach and rides and hot dogs, for decades, and especially in the pre– and post–World War II years, Coney Island was a magnet for New Yorkers looking for a refuge from the summertime heat of the city. The huge beach and boardwalk could accommodate millions every summer and several amusement parks, including Steeplechase Park and Luna Park, provided all manner of rides and entertainment, including the venerable Coney Island Cyclone, a huge, albeit creaky, wooden rollercoaster that still operates.

But the parachute jump doesn't—although the structure remains. Its appeal faded and the ride closed for good in 1964, when Steeplechase Park closed. And, if Donald Trump's father had had his way, the tower itself would have been razed to the ground—not once, but twice.

Fred C. Trump, who gave us Donald, was a real estate developer of New York's outer boroughs in the 1960s who, among other things, refused to rent apartments to blacks.

according to a suit brought by New York State. (He and Donald settled out of court, admitting nothing.)

After Steeplechase Park closed, the elder Trump bought and razed the property for another housing project, with an eye toward tearing down the parachute tower. But the controversial project fell through amid strong local opposition and the tower was saved. In fact, the tower was declared a city landmark in 1977, but within years, the city council reversed itself, saying that protecting such valuable land from development was a luxury that the then-cash-strapped city could ill-afford. It was not until 1988 (with the city in comparatively better financial shape) that the Coney Island parachute reclaimed its landmark status, but not before Fred Trump, still eager for the land, offered the city $400,000 to tear it down.

Sorry Fred, the city said, it's a landmark (again).

But Trump was right about one thing. After decades of decline in the postwar years, Coney Island was ready to be reborn. Today, it not only features its venerable rides and boardwalk, but also a new ballpark on the site of Steeplechase Park, home to the Mets-affiliated New York Cyclones minor league baseball team, as well as the New York Cosmos soccer club. Combine that with Nathan's annual hot dog eating contest, Coney's over-the-top Mermaid Parade at the beginning of summer (think Mardi Gras with a gay, feminist, what-the-hell-let's-party slant) as well as the fact that the parachute tower now has a brand new $2 million set of LED lights to make it shine in the night (much as the Eiffel Tower does now) and you probably don't have to worry about Coney Island's future as a place to kick back, eat well, and raise hell.

EPILOGUE

Growing up in the Bronx in the postwar 1950s, I got from my parents an appreciation of music and theater by actually going to the Met and to shows on Broadway. The great museums—MoMA, the Guggenheim, etc.—were just a subway ride away. Living within walking distance of Yankee Stadium, I saw Mantle and Berra play there in the flesh.

I could not have experienced any of this growing up in Keokuk.

This was, after all, "B.I.": before the Internet. Before the era of Google, cell phones—the World Wide Web and all of its sticky, immediate, and deceptive connectivity.

If you wanted to experience something back then, you had to be there. You went to the ballpark, the theater, the concert, the reading, the lecture. TV coverage, if it existed at all, was in black and white, or small-screen color. Live streaming was something for trout.

Things were smaller, too. Granted, Yankee Stadium and the Willie Mays–era Polo Grounds were pretty big places, but Ebbets Field in Brooklyn was human-scale. When I went to rock concerts in the early 60s, Jerry Lee Lewis, Jackie Wilson, and Little Richard tore things up in movie theaters like the Brooklyn Fox or the Brooklyn Paramount—not in super-sized "plexes" or huge arenas like Barclay's (also, as it happens, in Brooklyn).

Food was smaller. A bottle of Coca-Cola was a mere 6.5 ounces. A hamburger at a lunch counter was a thin patty on a white bread bun, not a ground side of beef on an artisanal brioche. An ice-cream cone was just that: one average-sized scoop, usually vanilla or chocolate, in a waffle cone (sprinkles optional) not a half-pint of salted caramel ripple in a tub. And it cost ten cents.

But perhaps what I recall most from my years in New York and my extended stays in Paris was the slower pace of life in general.

The Internet today hammers us with information, good and bad, real and fake, every single minute—a constant drumbeat that seems to inform us yet also leaves us numb and strangely disengaged. Not to mention hideously ill-informed.

Granted, to those of a certain age (i.e., me) disengagement might sometimes be welcome, given all that we've lived though.

Fifty years ago—in 1968, and the start of my life as a reporter—America endured one of the most tumultuous years of its modern history. It was the year in which both Democratic presidential candidate Robert F. Kennedy and the Rev. Dr. Martin Luther King, Jr. were assassinated, triggering bloody riots in several American cities, several of which I covered. That same year, in the then-raging Vietnam War, the Tet Offensive put paid to the idea that we were winning that unwinnable war. Shortly thereafter came the My Lai massacre and by year's end nearly 17,000 Americans had been killed in the deadliest year of the war.

If that were not enough, in 1968 avowed segregationist George Wallace ran for president, winning an appalling 46 electoral votes that November—and, months earlier at the Democratic National Convention in Chicago, local police (in what later came to credibly be called "a police riot") assaulted antiwar demonstrators so viciously that the National Guard had to be called in to help maintain order. (That convention actually was my second—my first was the comparatively sedate, near-coronation of Richard Nixon and his partner-in-crime, Spiro Agnew, a couple of weeks earlier in Miami. I had no idea what to expect when the Democrats convened. To a then twenty-one-year-old newbie reporter, Chicago was my baptism by fire.)

At the time it seemed as if the entire American social fabric were unraveling, but we survived—just as we survived the stock market crash of 1929, Pearl Harbor in 1941, not to mention the terrorist attacks of September 11, 2001.

Worth remembering today as we face an at-best uncertain future both here and abroad.

And that future always seems with us now. We are too much tethered to our devices, and to the false sense they give us of being in the world. Wondrous though it may be to have the world in the palm of your hand, at the end of the day all you are left with is your hand—not experience.

Sensation, not connection.

More people than ever may be traveling, but if one's main activity is making selfies, and not taking the time to immerse oneself in a different location or culture, what's the point?

And if one uses an iPhone merely to cocoon in an echo chamber of shared beliefs (and prejudices) what do we really accomplish?

The Internet has facilitated a globalization of culture, and you can see it in McDonald's in Paris and in Au Bon Pain in New York. But the Internet also makes it far easier to self-segregate in each city. If you're in Paris, you can surround yourself with artifacts of New York life—the food, the culture, the music, etc.—and never really immerse yourself in what Paris can offer. Same goes for the other side of the pond.

Ironically, the very technology that should enable us to actually connect as one humanity instead can be used to segregate us by everything from our buying preferences, to our reading habits, to our political beliefs, to our religion.

The world of New York and Paris 1960–80 was different: no Internet, no 24/7 news cycle, no smartphones, no Siri or Alexa. Your friends were real, not ones mined by the dozen on Facebook. You literally had to stop and smell the coffee, or the baguettes. You lived life as it happened to you, not to your avatar.

And you literally had time to breathe before the next onslaught of news. The journalistic day was divided between a.m. and p.m.—usually morning and evening editions of a newspaper. On television, the news came on in the early evening for a half hour. In

between, people simply went about their lives, living in their own worlds, free from the eyeball-grabbing *agita* of all-news-all-the-time.

If life was slower "B.I.," was it also better? That's a loaded question that really depends on the individual. The real question to ask, after going through a book like this, is whether the world of today—hardwired to an ever-faster treadmill, in which screaming passes for newsgathering and tweeting passes for leadership—actually is an improvement.

PLATES

ACKNOWLEDGMENTS

In the dim mists of history, when Neil Offen and I were freshmen at City College of New York, we were the two worst students in our required freshmen math class. I know we were the two worst because at term's end, our teacher, Mr. Siegman (who seemed to enjoy this) had each student who was in danger of failing stand up. Then he read aloud and in ascending order what each of us needed to get on the Math 61 final exam in order to earn a D and (barely) pass the course.

Neil and I were the last two standing.

"Mr. Van Riper," Siegman said in a clipped, nasal voice, "you need an 87 in order to get a D in this course."

Then he looked at Neil.

And chuckled.

"Mr. Offen," he said, "you need a 98…."

To this day, Neil wishes he had been quick enough to ask, "What do I need for a C?"

By the end of our freshmen year, having spent most of our time working on the college newspaper instead of studying, the two of us had been kicked out of CCNY. I managed to get back in on academic probation and ultimately graduate. Neil quit after his junior year. He went on to become one of the *New York Post*'s premier sportswriters, lived in France for nine years after that with his wife (and college sweetheart) Carol, and also had one of his books made into a movie.

Today I am grateful that Neil and Carol moved to France because, otherwise, this book probably could not have happened.

Many people helped make *Recovered Memory* a reality, but Neil and Carol helped the most. The manuscript for their unpublished book *C'est la Vie: An Intimate Portrait of the French Today* was invaluable in buttressing my own memories of Paris, as were their timely and trenchant edits of my own manuscript.

Their recovered memories—as well as those of other friends, especially photographer Erica Wissolik—made the Paris of yesterday come even more alive, and added depth and nuance to my text.

So too did bestselling author Martin Walker's eloquent foreword featuring recollections of the Paris and New York of his youth help set the mood for my work. I had never met Martin, a Brit and author of the popular France-based Bruno, Chief of Police detective novels, but he was an ex-UPI foreign correspondent and knew my friend and

colleague Bob Cullen (ex-*Newsweek* correspondent). Bob made the email introduction and literally within twenty-four hours after seeing my photos and text, Martin came through, one journo to another. My sincere thanks to all.

Thanks, too, to Michael Itkoff of Daylight Books, who read my book proposal and immediately offered me a contract. (It doesn't always happen that way.) Ursula Damm, Daylight's creative director, designed a jewel of a book and sequenced my images beautifully, creating juxtapositions of my Paris/NY photos that I never would have seen. Barbara Richard, my (minimally invasive) copy editor, wielded her pencil deftly and supportively.

Bruce Paul Gaber, a gentle-natured video artist (and excellent photographer) produced a wonderful promotional video for me. Mille grazie a tutti.

Finally, I offer my love and gratitude for the unending support I receive from my wife and professional partner, Judith Goodman, with whom I have worked since before we were married. It has been a long joyful ride that I have cherished. Publication of *Recovered Memory* coincides with our thirty-fifth anniversary—reason to celebrate, I would hope, in New York and Paris.